IMAGES
of America

PRINCETON
BY-THE-SEA

The Ocean Shore Railroad promised its passengers fresh sea air and dramatic ocean views. These visitors enjoy the public pier at Princeton-by-the-Sea. Later, during Prohibition, local rumrunners used the pier to transfer their cargo of illegal whisky. In the 1940s, abalone was processed at the wharf, and Hazel's fleet of vessels used it to board recreational fisherman for a day on the surf. When the Pillar Point Breakwater was constructed in the late 1950s, it was consigned to history. (Courtesy R. Guy Smith.)

ON THE COVER: Pictured from left to right are Hazel ("Big Hazel") Dooley, Mary Teixeira, Helen Fretwell, Antone Teixeira, and Marie Anderson. In the 1940s, Big Hazel (far left, wearing apron), co-owner of Hazel's Seafoods, gossips with friends outside her popular restaurant in Princeton-by-the-Sea on the San Mateo County Coastside. (Courtesy Larry Teixeira.)

IMAGES
of America

PRINCETON
BY-THE-SEA

June Morrall

ARCADIA
PUBLISHING

Copyright © 2007 by June Morrall
ISBN 978-0-7385-5583-6

Published by Arcadia Publishing
Charleston SC, Chicago IL, Portsmouth NH, San Francisco CA

Printed in the United States of America

Library of Congress Catalog Card Number: 2007931270

For all general information contact Arcadia Publishing at:
Telephone 843-853-2070
Fax 843-853-0044
E-mail sales@arcadiapublishing.com
For customer service and orders:
Toll-Free 1-888-313-2665

Visit us on the Internet at www.arcadiapublishing.com

In the early part of the 20th century, these Ocean Shore Railroad passengers return to San Francisco after an enjoyable day on the Coastside. (Courtesy R. Guy Smith.)

Contents

Acknowledgments		6
Introduction		7
1.	The Ocean Shore Railroad Reaches the Beaches	11
2.	Rumrunners and Roadhouses	23
3.	Hazel's and the Tidal Wave	35
4.	Ida's and a Small Cannery Row	51
5.	Pioneer Drag Racers and Magnificent Surfers	75
6.	Pete Douglas and the Beatniks	87
7.	The New Mavericks	105

Acknowledgments

I was fortunate to have the help of Bill Claudino, who connected me with Larry Teixeira. Larry's parents owned Hazel's Sea Foods in Princeton. It was good to meet Maryanne Dimare, also a part of the big, warm Teixeira-Dooley family. Mark Andermahr, whose love of the Half Moon Bay Drag Strip is evident by looking at the vintage photographs on the walls of his Half Moon Bay Bakery, put me in touch with the gracious Jeanne Bogue and her knowledgeable, abalone-diving brother, Ron Mangue—the children of Ida and Ernie Mangue. Charlie and Frank Romeo welcomed me to Romeo's Fertilizers, their family's historic business location in Princeton. I have been interviewing the always-inspirational Pete Douglas at the Bach Dancing and Dynamite Society in Miramar for years. Linda Goetz helped in any number of areas. Many thanks to renowned artist Michael Bowen (www.beatscene.com), who was generous in many ways. Linda Montalto Patterson kindly invited me to her spectacular gardens at the Hastings House in Miramar. It is always an adventure to visit Michael Powers, whose fantastic art is integrated into his home.

Thanks as well to the following: Barbara Walsh of Barbara's Fishtrap, Cherie Dailey, Pamela Moyce of Snow Angel, Susan Mauer, Bob Resch of Princeton Welding, Daniel and Celeste Bass of West Coast Surgical, Jenna Kinghorn, Fitzgerald Marine Reserve, and Susan Morgan of Elegant Cheesecakes. I had a good visit with Lisa Petrides, president of the Institute for the Study of Knowledge Management in Education (ISKME) in Princeton. Jeff Clark was generous and informative. I am grateful to photographer Jerry Koontz whose images grace these pages—and to photographers Edward Davis, Michael Wong of Spring Valley Gallery, and Aric Crabb of Crabb Photography. Additional historic images came from Rosina Gianocca, Randolph Brandt, Tom Gray, and Don Waldrod. I would like to thank the following institutions for being enormously helpful: the California State Library at Sacramento, the Spanishtown Historical Society, the University of California at Santa Cruz Map Room, and the San Mateo County History Museum. Thank you to my longtime companion, Burt Blumert, who put me in touch with the great drag racer "Big Daddy" Don Garlits. I alone am responsible for any errors or omissions.

Introduction

This was Prohibition: high-powered boats running without lights, speeding to avoid Coast Guard vessels; small fishing craft laden with illegal booze, waiting to deliver their contraband; the lives of everyday Coastsiders turned topsy-turvy. During this war between the bootleggers and the feds (with colorful characters on both sides of the law), dramatic events were acted out on the secluded and breathtakingly beautiful San Mateo Coastside.

Once the whiskey was smuggled down from Canada, the rumrunners often hid the booze under fake, floating kelp beds near Pillar Point. At midnight, they used code books and flashlights to communicate with their confederates on shore, and when the "coast was clear," innocent-looking fishing boats moored at Princeton harbor set out to pick up the contraband. An unlucky craft that encountered the Coast Guard might try to outrun the authorities, but even if trapped, all was not lost. The locals knew every wrinkle of the shore and coastal waters, and after a few tense moments, the fisherman and his booze would often safely get away. Alcoholic beverages had become illegal, but this seemed to make San Franciscans thirstier than ever before.

In the 1920s, life in Princeton-by-the-Sea and Miramar Beach was dominated by the industry of Prohibition. Clever rumrunners and bootleggers were coming and going. Most were homegrown, and all were fixated on making a buck and outsmarting the authorities. Princeton and Miramar are located not too many miles south of San Francisco, where much of the booze was destined, and its spectacular coastal mountains created a perfect barrier that made the Coastside isolated, sparsely populated, and resistant to change.

In Miramar, the red-headed madam called Maymie operated one of the busiest roadhouses. The second story provided endless, unobstructed views of the Pacific, but that was not why her patrons made the trek upstairs. She presided over a 10-room bordello, hiring girls who were passing through. Downstairs Maymie served good, aged whiskey to customers, including many of the elite from Half Moon Bay, the "big" town four miles south. Her downstairs clients included the local judge, the president of the bank, and their wives. Maymie, the only woman who owned a Prohibition-era roadhouse, faced the same perils as her male counterparts. The local police or federal agents could show up at any time, confiscate whisky, and make arrests. A roadhouse owner's first line of defense was to hire carpenters to install custom-built hidden cabinets, removable slats in the flooring, and other imaginative, secret places to hide cash and whiskey. Maymie's carpenters had done a first-rate job.

The roadhouse was where the customer plunked down his two bits for a shot, but rumrunning was big business. It required men with money and influence. Princeton's kingpin was Johnny Patroni, the man who controlled the flow of booze. He owned the two-story Patroni House hotel and the indispensable wharf across the way where small fishing boats could glide alongside and deliver cargo. Patroni had established relationships with big-time Canadian smugglers who were much tougher than the locals. However, Johnny Patroni was a wily fellow who could match guile with the best—or worst—of them.

The Italians had come to the Coastside as poor immigrants in the 19th and early 20th centuries, toiling alongside the hardworking Portuguese who had arrived even earlier as whalers when those giant mammals were still being hunted. Prohibition offered equal opportunity to everyone, and the Italian and Portuguese communities proved to be very efficient at the business. Johnny Patroni, for example, was a practical entrepreneur who took all measures to safeguard his enterprise. Local officials on his payroll gave him sufficient warning when agents were headed over the mountains to raid and make arrests. There were actually very few raids and arrests, but even "Boss" Patroni was put in a compromising situation on one occasion when he did everything to save his own skin. The curtain came down on Prohibition in 1933. The Coastside had been the biggest supplier of booze on the West Coast. The "noble experiment" was a high point for both Miramar and Princeton but not their first brush with fame—or with notoriety.

California's history is deeply influenced by its early Mexican and Spanish roots. Long before California joined the United States in 1850, large chunks of land called ranchos were granted to political cronies of the Mexican regime. Princeton and Miramar were once part of larger ranchos. After the United States won the war against Mexico in 1848, the ranchos were broken up and the land slowly sold off in what must have been extremely complicated cases. The original property lines in the grant documents were often designated by geographical features like rocks and streams. This did not simplify matters for buyers and sellers. And getting to the Coastside was no easy task.

One very early, determined American settler had to lower his wagon down a steep mountainside with a sturdy rope before he followed, probably tripping and falling the entire way down. But if getting in was difficult, finding an outlet became a consuming passion. Most everything the early Coastsiders could not provide for themselves had to be shipped by stagecoach from San Francisco. The city was only 30 miles away, but it was a torturous journey. The locals needed coal; they wanted faster mail delivery. The solution was obvious: a pier that could accommodate small vessels from San Francisco. Little steamers delivering cargo would not be departing empty. The farms surrounding the Coastside produced legendary vegetables, and a pier would be a boon for the local growers.

Finally in the 1860s, politicians and entrepreneurs at Miramar pooled their resources and built a large wharf stretching deep into the Pacific. A tiny seaport village popped up around it with a warehouse, bars, and boardinghouses, all operated by the Irish Mullen family. The town was called Amesport, honoring the man who had developed the project. It was a big success for a time, but the weather was unpredictable, and by 1900, the seaport known as Amesport had vanished forever. Nevertheless, the passion to open the Coastside up to the world persisted. Some believed that a breakwater and a real harbor were desperately needed, especially after a group of local fishermen tragically lost their lives in a horrific storm in 1911. The incident led important locals to an urgent meeting at the Patroni House where they discussed safer conditions for Coastside fishing craft. Those who advocated a breakwater, however, would have to wait many decades before that became a reality.

The ambitious but doomed Ocean Shore Railroad planned to carry passengers south from San Francisco to Princeton and Miramar, and farther south to Half Moon Bay. Near Princeton and Miramar would be a Coney Island–West atmosphere with restaurants, hotels, and places to dance and play. The Ocean Shore would be the railroad that, according to advertisements, "Reaches the Beaches." Constructing the railroad proved to be an engineering miracle, virtually blasting through the mountain range, but nature would not be kind to the promoter's grand plan. Heavy rocks and boulders tumbled onto the tracks at the notorious Devil's Slide, wreaking havoc with the passenger schedule, and then the devastating 1906 San Francisco Earthquake tolled the bell for the "Reaches the Beaches" railroad. The Ocean Shore went bankrupt about 1920.

Why did early residents name the town Princeton? Blame it on Frank Brophy, who, caught up by the railroad's grandiose ideas, bought the land and built and named the charming Princeton Inn. Legend has it that Princeton was the name of Brophy's dog. The little fishing village adopted the name as its own and went even further by designating the Princeton streets as Stanford,

Harvard, Columbia, Yale, and so on.

Miramar, translated as "to behold the sea," also came to life during the heyday of the Ocean Shore Railroad. One magnificent architectural gem of the time was the artfully shingled Palace Miramar Hotel, which featured windows overlooking the soft sand dunes and the Pacific Ocean. Owner Joe Miguel and his children also repaired the abandoned Amesport Pier, which was transformed into a delightful place to walk, fish, and take photographs.

In the 1940s, Princeton emerged as an important commercial fishing center. Fishermen from all over came to harvest the sardines teeming in the surrounding waters. At the industry's peak, Princeton's two canneries—Romeo's and Princeton Packers—processed the valuable sardines. It was as if Princeton had developed its own small Cannery Row. Sardines were not the only prize in this place, one of the best fishing banks on the West Coast. On a single day, hundreds of abalone were collected off Pillar Point by elaborately suited divers. During World War II, local fishermen had another windfall when the federal government paid high prices for shark livers, the source of Vitamin B-12, given to air force pilots to improve their vision.

Then a great mystery. One day, the sardine schools simply disappeared from the waters outside Princeton—gone south to Mexico or South America. Overnight the canneries closed, and any sardine-related businesses were padlocked forever.

World War II had a significant impact on the Coastside. The military occupied public buildings and the Palace Miramar Hotel. Several young ladies serving as Women's Air Force Service Pilots (WASPs) were headquartered near the crude Half Moon Bay Airport. The WASPs flew PQ14s, towing targets for artillery crews to practice shooting.

Folks have been coming to Princeton for decades, lured by the outstanding, modestly priced seafood. Colorful restaurants with larger-than-life owners like Hazel's and Ida's were part of every Coastsider's life. Hazel, for example, hired all the pretty girls on the Coastside as her waitresses. This meant that the boys would be sure to show up on Saturday night. Hazel got the lads to clean the restaurant's walls while waiting for the girls. Their work done, the kids took off on their Saturday night festivities.

Throughout the years, the Coastside has drawn its share of celebrities. While cracking a delectable Dungeness crab at Hazel's, you might catch a glimpse of Marilyn Monroe and Joe DiMaggio huddled at the next table or Jimmy Stewart, while the film *The Spirit of St. Louis* was being shot nearby. Another celebrity regular at Ida's Seafood Grotto was singer "Tennessee" Ernie Ford, renowned for his smash television show.

Developer Henry Doelger first visited Princeton on a camping trip when he was just a boy in 1912. He vowed to return. Years later, he owned many of Princeton's buildings and would rent them to locals. The Mangue family, who operated Ida's Restaurant, was a tenant. On a lovely evening in the 1950s, Doelger sailed his lavish yacht into Princeton harbor and told Ida he wanted a fresh prawn dinner. Ida's kids, Jeanne and Ronnie, jumped into a rowboat and delivered the prawn dinner while it was still hot. Doelger, who had successfully developed Westlake, a major San Mateo County subdivision, had plans for turning Princeton into a resort with a flashy Polynesian theme, but that grand scheme never materialized.

Through good economic times and bad, Princeton and Miramar remained isolated. Some newcomers appeared, but no one had more impact on Miramar in the late 1950s than Pete Douglas. He was passionate, irreverent, and driven by his great love for all music, especially jazz. This passion led Douglas to establish the long-running Bach Dancing and Dynamite Society in 1958. For almost 50 years, the Bach has attracted the world's best musicians, to the delight of Miramar audiences.

At about the same time, residents of North Beach in San Francisco became irritated with a group of their talented but unusual neighbors. These artists, derisively called the "beatniks," became unwelcome in North Beach. Some felt so unwanted that they packed their bags and departed San Francisco as a whole. This small group of beatniks, including artist Michael Bowen, then discovered Princeton, finding refuge in the Abalone Factory, a house that had been used to process abalone. Predictably, the locals called the building the "Beatnik House" and probably

never noticed that poet Allen Ginsberg paid a visit there and that singer Janis Joplin dropped by on her way to San Francisco. In fact, almost every artist from that era, at one time or another, visited Princeton's Beatnik House.

In the 1950s and 1960s, the world's best drag racers competed at the Half Moon Bay Drag Strip, near the same airport where the WASPs had flown PQ14s during World War II. "Big Daddy" Don Garlits and his nemesis, Don "The Snake" Prudhomme, were drag-racing superstars whose exploits are still discussed. Since the end of the drag strip, the annual Dream Machine event has taken its place, showing off incredible planes, automobiles, and other amazing machinery. At Pillar Point today, the finest surfers in the world come to conquer the 70-foot-high waves at Mavericks, culminating in a much-heralded yearly competition.

When you visit Princeton and Miramar now, many traces of the past remain. The Princeton Inn still stands, and Princeton itself retains a funkiness reminiscent of days gone by. Hazel's is still there but is now called Barbara's Fishtrap. Ida's is gone; in its place is the Half Moon Bay Brewing Company, a magnet for younger crowds. At Miramar, although Maymie the red-haired madam is gone, her Prohibition roadhouse remains, and nearby impresario Pete Douglas still hosts quality music at the Bach.

While Princeton remains home to some fishing, it is mostly a white tennis shoe harbor. Today in the old fishing village, you find upscale new businesses and enterprises nestled near piles of stored crab traps and boats in dry-dock. You can order an expensive, custom-designed cheesecake, get advice from an educational research institute, or buy a surfboard at Mavericks, which is operated by surfing icon Jeff Clark.

One

THE OCEAN SHORE RAILROAD REACHES THE BEACHES

The Ocean Shore Railroad promoters had "pie in the sky" on their minds when they began ferrying passengers to the rarely seen beaches on the other side of the notorious Devil's Slide. In 1908, the waiting list for tickets grew so long that the company had to add open-air cars to accommodate the demand for the exciting "Reaches the Beaches" excursion. The folks riding in the open air had to hang on to their hats, as the trip was a lot like a thrilling roller coaster ride on the edge of real cliffs overlooking a real ocean. (Courtesy Randolph Brandt.)

This vintage map indicates the proposed route of the Ocean Shore Railroad from San Francisco south to Santa Cruz. The 1906 San Francisco Earthquake caused expensive equipment standing at the fragile Devil's Slide to slip and slide into the cold Pacific Ocean. Even more damaging to the Ocean Shore's chance for success was competition from the automobile. The "Reaches the Beaches" railroad failed to accomplish its lofty goal, dead-ending at Tunitas Creek south of Half Moon Bay. The iron road was removed in 1920 to make way for a cement road friendly to cars with rubber tires. The Ocean Shore's legacy is a string of beach towns, including Miramar and Princeton-by-the-Sea, communities that remain unique to this day. (Courtesy San Mateo County History Museum.)

Sybil Easterday was a celebrated, eccentric sculptress, famous for the men's trousers she wore while working with clay. Her studio was located at the end of the line for the Ocean Shore Railroad at lonely Tunitas Creek, as was her husband's joyless saloon. In 1916, Sybil's husband, Louis, would take his own life. (Courtesy San Mateo County History Museum.)

12

A funnel of thick black smoke spews from an Ocean Shore train racing north from Tunitas Creek to San Francisco. It has dropped passengers off near Princeton at the North Granada Station. In the background, barely visible, stands the first pier built in Princeton, dating this photograph as pre-1920. Note the barn adjacent to the pier. (Courtesy Rosina Gianocca.)

The Ocean Shore Company built beautiful train stations on the Coastside. The graceful North Granada Station still stands but has been significantly remodeled over the years. Passengers destined for the beaches at Princeton and Miramar exited the train here. (Courtesy Rosina Gianocca.)

At first, the Ocean Shore Railroad had no problem enticing potential lot buyers and lovers of the Coastside to Princeton and Miramar. They got off the train at the North Granada Station and were guided down a dirt path to the lovely beach for a bag lunch and a sales pitch about this new area. (Courtesy Rosina Gianocca.)

Once visitors were comfortably seated on the sand or on a driftwood raft, the real estate men took over, listing all the reasons why purchasing a lot in this isolated part of San Mateo County was a good investment. In the early 1900s, the typical lot was sized at 25 by 50 feet, indicating that the homes were expected to be small and modest. (Courtesy Rosina Gianocca.)

There were many things to do and see along the once-remote beaches of Princeton and Miramar. The beautiful Palace Miramar Hotel, now gone, was built about 1917 not only to attract railroad passengers, but also those with licenses to drive motorcycles and automobiles. (Courtesy Rosina Gionocca.)

While the Ocean Shore's "Reaches the Beaches" excursion was a novelty, the opportunity to drive an automobile to the edge of the sea with friends in the backseat trumped every other method of travel. In 1913, these folks parked overlooking the crescent-shaped Half Moon Bay between Miramar and Princeton. (Courtesy California State Library.)

When it comes to piers, Princeton and Miramar have much in common, as both beachside communities had early constructions. The public pier, pictured here and no longer standing, may well have been known earlier as Old Landing where local produce was loaded on little steamers. In the background, Princeton thrives during the railroad era; the most dominant building is the two-story Patroni House. (Courtesy Rosina Gianocca.)

The Princeton Inn, built in the early 1900s to accommodate Ocean Shore Railroad passengers, is one of the town's oldest extant structures with an intriguing history to match. (Courtesy Rosina Gianocca.)

The July 6, 1912, issue of the *San Francisco Call* was devoted to the Ocean Shore Railroad's progress on the Coastside, focusing on Princeton and the Hotel Princeton. Dressed in their Sunday best, people mill about outside the hotel before celebrating the Fourth of July by dancing to an orchestra at the nearby amusement park. The Hotel Princeton was built by Frank Brophy, who also bought the land known as Princeton-by-the-Sea, which, according to local lore, was named after his dog. (Courtesy California State Library.)

This pre-1900s map showing the early route of the Ocean Shore Railroad indicates its age by the use of "Spanish Town," an early name in common use until about 1900 when the place became known as Half Moon Bay. Amesport, which the railroad renamed the more romantic Miramar Beach, was the site of the wharf built in the 1860s and the little rough-and-tumble fishing village that grew up around the pier. (Courtesy San Mateo County History Museum.)

The small seaport called Amesport was once located near here. Just out of view would have been the Amesport Wharf where steamers called to pick up locally grown potatoes and to deliver mail and coal for heating. (Courtesy Rosina Gianocca.)

In the early days, the fertile land at Miramar and Princeton was devoted principally to the farming of artichokes, and the "chokes" were so superior and delicious that the countryside soon became known as the "Artichoke Capital." In the distance, standing guard over Princeton, is Pillar Point, the famous landmark that settlers called Snake's Head. (Courtesy Rosina Gianocca.)

Life was idyllic in early Miramar, and even the feud between the Irish Mullens and the Portuguese Miguels was more entertaining than harmful. For years, John Mullen walked from his farmhouse, seen here and extant today, to Amesport, the wharf he managed. When the wharf went out of business, artichoke farmer Joe Miguel bought the property. This led to big trouble between the two families, especially when Miguel had the foresight to build the grand Palace Miramar Hotel where Mullen's beloved wharf had stood. (Courtesy Rosina Gianocca.)

The Mullens were further antagonized when the Miguel family constructed this still-standing home within eyeshot of the Mullen farmhouse. At one point during an argument over a horse, a bullet found its way into the Mullens' fence. (Courtesy Rosina Gianocca.)

A more serious incident occurred in the 1900s in Miramar at Pete Gianni's saloon and store where local Italians met to dance and drink homemade wine. Known for his hot temper, Gianni fell into an argument and shot a tenant to death. He was sentenced to life imprisonment at San Quentin, a torrid story the old-timers never forgot. (Courtesy Spanishtown Historical Society.)

Locals say the Hastings House was rolled on logs from another Coastside location to Miramar Beach in the early 1900s. It was named after a realtor who raised her family in the home. Now owned by an artist and classical guitarist, the residence has been embellished with a lush rose garden, making it a gorgeous venue for romantic beach weddings. (Courtesy Linda Montalto Patterson.)

Another building still standing in Miramar is the old Gilles Store, once operated by settler Margaret Gilles. Now a private residence, it provides a good example of the false-front architecture so common in the early 1900s. (Courtesy Jerry Koontz.)

Frank Brophy, who purchased the land near Pillar Point and called it Princeton-by-the-Sea and who built the Princeton Inn to serve passengers on the Ocean Shore Railroad, must have had Ivy League universities on his mind. All the streets in Princeton are named after institutions of higher learning such as Stanford, Harvard, and Columbia. Interestingly, no schools of any kind have opened in this village, which has historically been devoted to fishing. (Courtesy Rosina Gianocca.)

Joe Miguel got it just right when he built the Palace Miramar. As soon as the Ocean Shore Railroad tore up its iron road to allow for a highway, automobile parties headed for Miramar Beach where fresh steamed mussels were served at the restaurant overlooking the pier. (Courtesy Rosina Gianocca.)

Two
Rumrunners and Roadhouses

Husky Giovanni "Johnny" Patroni was the *padrone*, the boss, of Princeton in the 1920s. Born in Genoa, Italy, in 1878, this son of farmers learned the hotel business in San Francisco before moving to Princeton in the early 1900s. He also formed a partnership with artichoke farmer Dante Dianda. Together they owned 400 acres. In 1921, with the collapse of the Ocean Shore Railroad, Princeton was a failed resort, and residents were ready for any kind of business. When Patroni was 43, Prohibition started, and bootlegger Thomas Murphy approached the restaurant owner, convincing him to let his wharf be used to unload illegal liquor. Soon after, fishing boats delivered thousands of dollars of illegal whiskey from Vancouver, British Columbia, to Patroni's Wharf in Princeton. (Courtesy Larry Vellutini.)

23

In the 1920s, popular redhead Maymie Cowley was the "boss lady" of Miramar. The Midwesterner traveled to California, opening a lively roadhouse and bordello north of Half Moon Bay. For locals, it became customary to celebrate birthdays at Maymie's, buying drinks for everyone. (Courtesy John Muehe.)

Note the cars parked outside and the closed curtains on the second floor of the Princeton Inn, a bordello that was raided and its owners cited for breaking the so-called "red light" law. The old hotel was also raided for serving illegal whiskey during Prohibition. (Courtesy Rosina Gianocca.)

The harbor is just steps away from the Princeton Inn. During Prohibition, great escape artist Harry Houdini was reportedly hired by the U.S. Treasury to dive for a hidden cache of booze in the bay. (Courtesy Jerry Ohlinger.)

In the mid-1920s, the independent film company Peninsula Studios shot the silent film *Let Women Alone*, starring actor Wallace Beery, in Prohibition-era Princeton. Featuring an exciting boat chase on the high seas, the movie was printed on fragile nitrate film. At the time, it was unusual to shoot on location. Although the historic film may contain treasured views of Princeton, no one has been able to locate copies, and it is feared lost. (Courtesy Jerry Ohlinger.)

The mountainous barriers kept the agricultural Coastside secluded and isolated—and the bootleggers successful. When the San Mateo–Half Moon Bay Road (Highway 92) was closed for repairs, it presented a serious problem for rumrunners. They had to find alternative routes to deliver booze to San Francisco. They often went south to Santa Cruz and then crossed over the mountains. This increased the risk of encountering other rumrunners or Prohibition agents, both after their cache of booze. (Courtesy San Mateo County History Museum.)

Another option for rumrunners was Pedro Mountain Road. From atop the mountain, it looked like an unfurling ribbon of concrete with endless views, infamous for its hairpin turns and switchbacks. The locals dubbed it the "Rumrunner's Road" because bootleggers in high-powered machines dodged bullets from rivals in their rush to get whiskey to the restaurants and hotels in San Francisco. (Courtesy Rosina Gianocca.)

Local rumrunners, many of them fishermen who lived and worked at Princeton, were ingenious when it came to concealing illegal alcohol coming in from Canadian "mother ships." There were secret coves and caves for hiding whiskey—places with names like Whaler's Cove and Beluga Beach—that only the fishermen knew about. Leftover pieces of old shipwrecks like the *Rydal Hall* offered additional nooks and crannies to hide booze. (Courtesy Ken Lajoie.)

Fishermen tossed a big heap of brown seaweed onto homemade floats that were attached to ropes anchored on the beach. Whiskey bottles were concealed beneath the kelp, and when the time was right, the float was pulled onto shore. (Courtesy Jerry Koontz.)

Today locals whisper stories of the Princeton rumrunners, fishermen who sometimes had to outrun the Coast Guard, which was headquartered in this small building, the current home of the Half Moon Bay Yacht Club. (Courtesy Jerry Koontz.)

On one occasion, a fisherman-rumrunner was caught between two piers in Princeton. Using guile and speed, he was able to get his fishing boat out of the tight corner and run for freedom and safety. (Courtesy Rosina Gianocca.)

This rare view shows three of the Coastside roadhouses: Rectors Tavern (left), the railroad-era Princeton Inn (center), and the imposing Patroni House. (Courtesy Rosina Gianocca.)

While Prohibition consumed the daily lives of many Coastsiders, residents talked of building a tunnel or somehow circumventing Devil's Slide, the geographical barrier that had caused such headaches for the Ocean Shore Railroad. These dignitaries are most likely emerging from a highway meeting held at the Palace Miramar Hotel, visible in the background along with the skeleton of Amesport Pier. (Courtesy R. Guy Smith.)

Motorcyclists were welcome at the Palace Miramar Hotel. In this photograph, bikers celebrate the Fourth of July. (Courtesy Rosina Gianocca.)

Maymie Cowley (left) stands with an unidentified friend in front of her Miramar Beach roadhouse. During Prohibition, Maymie's live-in companion, a superior carpenter, reportedly helped custom-build revolving cabinets and other imaginative hiding places for concealing whiskey from the authorities. In addition to her reputation as a savvy businesswoman, Maymie did all the cooking at her restaurant; some guests actually came just for the clam chowder. (Courtesy John Muehe.)

Motorcycle parties often rode their bikes to the beach, a practice that would be frowned upon today. The sand is tattooed with the swirls of their tire marks. (Courtesy Rosina Gianocca.)

The road in front of Maymie Cowley's place (far right) almost looks like an extension of the flat, sandy beach. The van in this photograph belongs to R. Guy Smith, the noted photographer, postmaster, and electrician living in nearby Moss Beach. (Courtesy Rosina Gianocca.)

This view shows the same road in Miramar but from the opposite direction. Pictured in the 1970s, the beach appears eroded, and rocks have been placed on its sand to repel waves. What happened? Some say the beach erosion was occurring all along, that it was inevitable; others blame it on construction of the Pillar Point Breakwater, which funneled strong waves farther south to this part of Miramar Beach. (Courtesy Ken Lajoie.)

Motorcyclists enjoy a visit to the beach. Behind them is an excellent view of the historic New Columbus Hotel and other structures that no longer exist. This photograph is a true link to a big hole in the past. (Courtesy Rosina Gianocca.)

Coastside madam Maymie Cowley (center, with unidentified friends) grew old in Miramar Beach, living a quiet life upstairs at the Miramar Beach Inn until ill health forced her to move to Redwood City in the mid-1950s. She lived an extraordinary life, dodging raids and arrests during Prohibition and a possible murder that was officially declared a drowning when a young man's body was found floating in front of the roadhouse. In Half Moon Bay, rumors circulated that Maymie's live-in companion had not liked the fellow because he was paying too much attention to the madam. (Courtesy Rosina Gianocca.)

33

In 1921, Prohibition agents were tipped off about a shipment of illegal whiskey headed for Patroni's Wharf. Agents raided the two-story Patroni House, confiscating a small fortune in liquor. Arrested for violating the Volstead Act, Johnny Patroni confessed that he was a member of a major bootlegging ring that smuggled high-grade whiskey from Canada into the harbor at Princeton. Patroni was released and, in return for testifying before the grand jury, received immunity. He pointed the finger at Thomas Murphy, who confessed that he worked with a big Vancouver bootlegging ring that made deliveries to Princeton. All the legal machinations enthralled the Coastsiders, who knew that within days whiskey would be smuggled into Princeton once again. (Courtesy Tom Gray.)

Three
HAZEL'S AND THE TIDAL WAVE

On April 1, 1946, a tidal wave struck Princeton-by-the-Sea, terrifying residents and leaving the roads flooded and covered with debris. The tidal wave, which today would be called a tsunami, was the result of an earthquake near the Aleutian Islands in Alaska. More than 90 people died in Hawaii, but there were fortunately no deaths in Princeton where the tidal waves, several minutes apart, uprooted fences, flooded homes, and swept cars far from their parking places. The greatest damage was done to Hazel's Seafood Café, visible in the distance, which originally had been a simple seafood stand owned by Joe Bettencourt, a fisherman who also lived in Princeton. (Courtesy Larry Teixeira.)

When a tidal wave suddenly struck Princeton on April 1, 1946, it came as such a total surprise that it was immediately dubbed the "April Fools Tidal Wave." The result of the ruthless energy of the powerful waves is visible in the damage sustained by Hazel's Seafood Café. By this time, Prohibition was only a memory, and sardines, crabs, and abalone were big business in Princeton-by-the-Sea. (Courtesy Larry Teixeira.)

The April Fools Tidal Wave tossed about fishing boats as if they were children's toys, pushing this boat a half-mile inland. The U.S. Army Corps of Engineers had sent a crew to Princeton to study the feasibility of a new deepwater, sheltered harbor. The crew was standing on Romeo's Pier when the second wave rolled in (the third wave is supposedly the most potent) and fled the scene as fast as they could. Princeton fisherman and son of Joe, Ernie Bettencourt was stranded on the pier in his car but survived. (Courtesy Larry Teixeira.)

A young Hazel ("Little Hazel") Teixeira (left) and Hazel ("Big Hazel") Dooley stand in front of their restaurant, surveying the tidal wave damage. Somehow this photograph makes the destruction very personal. (Courtesy Maryanne Dimare.)

In more recent times, a severe storm accompanied by strong coastal winds pushed these boats like playthings onto dry land. Following the 1946 April Fools Tidal Wave, a complex breakwater was constructed to protect the harbor. There have been no recurrences of tidal waves or tsunamis since. (Courtesy Michael Wong.)

In this 1986–1987 California Department of Boating and Waterways aerial, the Pillar Point Breakwater is pictured in its entirety. (Courtesy UCSC Map Room.)

This spectacular aerial view shows most of the main buildings that comprised Princeton in the late 1940s when fishing was at its best and colorful seafood restaurants served the fresh, local catch. Hazel's Seafood Café stands at the far right with folks walking on the pier. This same spot has been known as the public pier and as Patroni's Wharf during Prohibition. On the opposite side of the road is the two-story Patroni House, with Patroni's family home standing farther back. Directly across the way from Hazel's is Nerli's Restaurant; next door stands a gas station. (Courtesy Larry Teixeira.)

Every year Capt. John Teixeira offered $100 for the biggest fish brought into the harbor. Here he holds the winner, a 50-pound salmon caught by local residents Leo Pecoraro and Clayton Gianocca. The Teixeiras moved to the Coastside in 1938 from Tracy, where the family had farmed. Hazel bought the fish stand from the Bettencourts. (Courtesy Larry Teixeira.)

Capt. John Teixeira held the controlling business interest in Hazel's Seafood Café. John, his wife, Hazel ("Little Hazel"); and his sister Hazel ("Big Hazel") opened the fish stand in 1943, the same year the captain started Hazel's Deep Sea Fishing Tours. In front of Hazel's was a refrigerator case filled with fresh, live clams and the assorted catch of the day. (Courtesy Larry Teixeira.)

The gorgeous, blonde bombshell Marilyn Monroe and famous baseball player Joe DiMaggio were regulars who could often be seen at Hazel's enjoying the famous clam chowder. DiMaggio is high on the list of all-time San Francisco Bay Area icons. When he was linked to Monroe in the early 1950s, the pair became the hottest news worldwide. (Courtesy 20th Century Fox.)

The Spirit of St. Louis, starring Jimmy Stewart, was released in 1957 and became a film classic almost overnight. Portraying great American aviation hero Charles Lindbergh, Stewart was a sure bet. Some of the exterior scenes were filmed near Princeton, and it did not take the actors and technical crew very long to discover Hazel's. (Courtesy Jerry Ohlinger.)

At the far end of Hazel's Pier stood a shack where the abalone was processed. The "ab," harvested off Pillar Point, was a staple on the menu at Hazel's and all the other nearby seafood stands and restaurants. (Courtesy Larry Teixeira.)

Old-timers swear that back in the day, six or eight dozen abalone could be bagged off Pillar Point in a few hours. The succulent abalone was processed at Hazel's, shown here, and at the Abalone Factory near the Princeton Inn. (Courtesy Larry Teixeira.)

Hazel's Fleet, as it was called, included several small commercial and charter boats. Here Captain John tows the *Hazel T.* to the wharf. (Courtesy Larry Teixeira.)

To board the *Hazel T.* at Hazel's Wharf, fishermen had to climb down a steep set of stairs to the water. The promise of fresh salmon drew weekend fishermen from all over who spent the day casting their lines into the fertile waters off Half Moon Bay. (Courtesy Larry Teixeira.)

When this group of dedicated anglers returned on the *Hazel T.* after a long, productive day of fishing, they posed with their bait boxes and other fishing gear. Behind them stands the processing shed for the abalone. (Courtesy Larry Teixeira.)

Another craft that was part of Hazel's Fleet was the appropriately named *Miss Princeton*. Locals became very sentimental toward the boats in the fleet. When the *Miss Princeton* became old and useless, she was beached and burned. Some felt she would have made a good mascot for Pillar Point Harbor. (Courtesy Larry Teixeira.)

The *Irene*, a beloved old fishing boat once owned by George Bettencourt, is being renovated to its former glory in Pillar Point Harbor's parking lot. In the early days, before the construction of Johnson Pier, she was called the *Emerald of the Bay* because she was everybody's favorite. (Courtesy Jerry Koontz.)

In the 1970s, former caterer Barbara Walsh and Pillar Point harbormaster Paul Whedoger opened their seafood restaurant in the old North Granada Station, also the site of Fred Lane's real estate office. At this location, Barbara had a kitchen "as big as a football field." Not long afterward, the couple purchased Hazel's restaurant in Princeton, changing the name to Barbara's Fishtrap, as it is still known today. (Courtesy Jerry Koontz.)

Before Hazel's name changed to Barbara's Fishtrap, it was called Biggies for a short time. Originally, Barbara Walsh's business catered to large groups such as the Half Moon Bay Farm Bureau and the Bach Dancing and Dynamite Society. (Courtesy Edward Davis.)

Barbara's Fishtrap is busier these days than ever before. Here Barbara Walsh poses with her "Fishtrap family" at the rustic restaurant's front door. Pictured from left to right are Kim Castillo, Gisela Lohman, Barbara, and head chef Raul Castillo. (Courtesy Jerry Koontz.)

When you visit this scenic path adjacent to Barbara's Fishtrap today, close your eyes and visualize the Patroni House directly across the street. Keep them closed, and you can imagine Patroni's Wharf bustling with rumrunners and bootleggers during Prohibition when Princeton was the biggest supplier of illegal booze on the West Coast. (Courtesy Jerry Koontz.)

Four

IDA'S AND A SMALL CANNERY ROW

Ida and Ernie Mangue moved from Pedro Point in Pacifica to Princeton in 1942, purchasing this crab stand from Joe Bettencourt, an ambitious fellow who also once owned Hazel's crab stand. At Ida's stand, fresh sardines, crab, abalone, and a new item, hot dogs, were sold. The abundant abalone that was bagged off Pillar Point was processed in the back of Ida and Ernie's house, called the Princeton Abalone Factory. It was steps away from their fish stand. (Courtesy R. Guy Smith.)

If you use a magnifying glass and look closely at the Princeton road sign in this photograph, you will be amazed that the population reads only 300. In spite of the town's size, there was an abundance of community for Princetonians. In the 1940s, you could still see a fisherman in his boat, alone, casting a line. For the kids growing up there, it was a magical place. Although nobody resided at the Patroni House, it was still standing, intact and fully furnished. If a local needed a chair or chest of drawers, he could borrow the item from the house and return it later. (Courtesy Rosina Gianocca.)

Princeton harbor is pictured in its natural splendor before construction of the breakwater. The San Mateo County Coastside was generously endowed with a black soil that earned Half Moon Bay the title of Artichoke Capital. The waters in front of the harbor constituted one of the richest fishing banks on the West Coast. (Courtesy Rosina Gianocca.)

In the 1940s, Princeton looked like a small Cannery Row where sardines were king. The Princeton Packers Company covered an entire square block, including the pier in the foreground of this aerial view. Hazel's pier had an abalone processing shed at its end. As always, the easiest building to identify is the two-story Patroni House in the center. Ida and Ernie Mangue's first home, the Princeton Abalone Factory, is the long, rambling house visible in the lower right corner. After the Mangues moved out, the factory was rented to a group of beatniks, including artist Michael Bowen, all of whom had been forced by their neighbors to flee North Beach in the late 1950s. (Courtesy Mark Andermahr.)

After the unexpected attack on Pearl Harbor in December 1941, the Pacific Coast was feared vulnerable to aggression by the Japanese. This resulted in a visible military presence in and around Half Moon Bay. Mildred Toner (left), Mary Lee Leatherbee (second from right), and Shirley Thackara (right) were three of the Women's Air Force Service Pilots (WASPs) stationed near Princeton at the Half Moon Bay Airport. The man in uniform is Lieutenant Nash. (Courtesy Shirley Thackara.)

Shirley Thackara smiles from the cockpit of her one-passenger PQ14. The WASPs' mission was to fly the PQ14s while towing targets to give antiaircraft gunners practical experience. The Coastside was chosen because of its sparse population; it was less likely that an accident would injure or kill civilians. (Courtesy Shirley Thackara.)

This photograph shows an early Half Moon Bay Airport at Princeton. It is difficult to tell for sure, but one of the three planes facing the tower may be a PQ14 that WASPs flew out of one small flight strip. At the airport were tents for the PQ14s, barracks for the GIs and officers, and a canteen. Down the road, the WASPs lived in what they dubbed "the fishing shack" because it lacked all the expected amenities. (Courtesy Rosina Gianocca.)

Like Americans all over the nation, customers at the Palace Miramar Hotel drank strong cups of coffee and listened intently to the latest radio reports updating the events of World War II. (Courtesy Rosina Gianocca.)

Joe Romeo (center) is flanked by his sons Frank (left) and Charlie. Joe owned a successful wholesale fish business in San Francisco when he decided to move the family to Princeton where sardines were abundant in the mid-1940s. (Courtesy Charlie and Frank Romeo.)

The Joe Romeo family constructed this pier and the building at its end, still called Romeo's Wharf. It is the only visible memory of Princeton's colorful sardine and cannery era when rugged, tough-talking fishermen ruled the harbor. (Courtesy Michael Wong.)

Joe Romeo named his brand of sardines Charlie Boy after his son Charlie. StarKist Tuna liked the name so much they bought it from Romeo, calling their animated icon Charlie the Tuna. StarKist's jingle was as follows: "We don't want a tuna with good taste; we want a tuna that tastes good." Joe Romeo's original Charlie Boy sardine labels launched the sardines-to-tuna-fame on its public relations journey in Princeton-by-the-Sea. Romeo closed the cannery when the sardines disappeared and then shifted to the more-profitable fertilizer business. The company produces fine blends of 300 different kinds of fertilizers today. (Courtesy Charlie and Frank Romeo.)

On a foggy day in Princeton-by-the-Sea, intrepid fishermen went about their business of hunting shark for the valuable livers that were in high demand by the federal government. The U.S. Army Air Force believed that the organ was a source of Vitamin B12 and that if administered to pilots, their vision would improve. Borden's in San Francisco was a big buyer of shark livers. (Courtesy Rosina Gianocca.)

Dominick and Connie Ortisi moved to Princeton when Dominick left the military in the 1940s. Like the others who came to Princeton in those days, the seafood business was attractive; they opened a crab stand and built a home nearby. Their house still stands as the present site of the American Legion. (Courtesy Mark Andermahr.)

Today this building houses the Café Capistrano and Old Princeton Landing. It was the site of the former Princeton Market, built by Dominick Ortisi. (Courtesy Jerry Koontz.)

The Larsons were another family drawn into the Princeton seafood business. Known as a colorful couple in the community, Emmet was a giant man and his wife, Frances, was as tiny as he was big. Larson's Crab Cottage served customers in a funky building at the edge of the Princeton Packers property. (Courtesy Edward Davis.)

Here is a real collector's item: a souvenir copy of the Larson's Crab Cottage menu. After owner Emmet Larson was killed in a tragic boating accident, the Crab Cottage remained vacant. In 1968, Tom Monaghan, his wife, Louise, and his mother, Mary, purchased the restaurant. The Crab Cottage burned in the 1980s. (Courtesy Susan Mauer.)

It is always fun to look at food prices from the old days. These are taken from Tom and Louise Mongahan's restaurant. On this Crab Cottage menu, the abalone entry is $8.75, while clam chowder, oysters, and rockfish are priced at around $2.75. Abalone has always been a luxury item, both then and now, if you can find it. (Courtesy Susan Mauer.)

FRESH SEA FOOD
CAUGHT FROM OUR OWN BOAT
TOM and LOUISE MONAGHAN, Proprietors

APPETIZERS
- CRAB COCKTAIL95
- SHRIMP COCKTAIL95
- OYSTER COCKTAIL95

DINNERS
includes french bread—french fries or rice
salad—tartar sauce

SHELLFISH
- BAKED ABALONE sauted in white wine, topped with *NOT ALWAYS AVAILABLE* butter and mushrooms—serving for two 8.75
- ABALONE STEAK with chowder 4.25
- PRAWNS 2.75
- BREADED SCALLOPS 2.75
- FRIED OYSTERS 2.75
- FRIED CRAB LEGS 2.75
- VARIETY SEAFOOD PLATE includes fish, oyster, prawn, scallops, abalone 3.25
- STEAMED CLAMS w/ecco ch. bread only 2.75

BROILED FISH
- SALMON STEAK .. (in season) 2.75
- FILLET DEEP WATER ROCK FISH (local) 2.50
- HALIBUT STEAK 2.75
- SWORDFISH STEAK 2.75
- Stuffed Prawns

DESSERTS
- HOMEMADE PIES45
- COFFEE—SANKA15
- MILK—ICE TEA20

FISH AND CHIPS 1.95
includes salad, french bread

SANDWICHES
with fries or rice
- ABALONE on french roll and salad 2.50
- FISHWICH 1.75
- CRAB SANDWICH and salad 1.95
- HAMBURGER85
- CHEESEBURGER95
- Grilled Cheese75

CLAM CHOWDER50
with french bread75

WHOLE COOKED CRAB .. 3.25

LOUIES AND SALADS
- CRAB 2.75
- SHRIMP 2.75
- COMBINATION 3.25

BEER
- IMPORTED BEER Dos Equis, Heineken (light) .75
- EASTERN or WESTERN BEER Oly, Coors, Millers .50

Chef Ernie Mangue poses in the kitchen of the original Ida's, called the Princeton Fish Grotto. The Captain's Plate, a specialty of the house, was composed of fresh prawns, scallops, oysters, fish fillet, and New England clam chowder. (Courtesy Jeanne Bogue.)

Eugene Pardini (left) and Ronnie Mangue, youngsters growing up in Princeton-by-the-Sea when this photograph was taken, proudly show off the 30-pound salmon they brought into the harbor, as Ronnie's beaming father, Ernie, stands in the background. (Courtesy Ron Mangue.)

The Pardini family still lives in Princeton, selling fresh fruits and vegetables near the present-day Mezza Luna Restaurant. Here Eugene Pardini (right) and his future son-in-law Bill Stokes enjoy a beautiful day in Princeton. (Courtesy Jerry Koontz.)

Pardini's fruit and vegetable stand is an institution on the Coastside. Somehow the display makes you want to eat the fruit on the spot. (Courtesy Jerry Koontz.)

At least two of the piers in Princeton are visible here: Hazel's (left) and Princeton Packers (right). In the background stands a radar-less Pillar Point. The giant radar dish would not come to the area until the 1960s, and when it did, its eerie presence immediately spawned rumors of space aliens landing and other UFO stories. (Courtesy Larry Teixeira.)

The giant, flat radar dish first appeared atop Pillar Point in the 1960s. In the era of moon flights and Sputniks, to some of the Princetonians the big dish represented a space-age symbol conjuring up visions of extraterrestrials. (Courtesy Edward Davis.)

Ronnie Mangue, standing in front of a small corner of the Abalone Factory, lived through the tidal wave of 1946. His sister Jeanne, who now runs a restaurant like her mother's in Fort Jones, California, also vividly recalls the terror of that April day. As the children of fishermen, Jeanne and Ron knew the third wave was the most lethal. And when that wave rolled toward them, it was scarier and more powerful than anything they had ever seen. (Courtesy Ron Mangue.)

This photograph dramatically illustrates the devastation of the tidal wave. It ripped off the front porch and steps of the house the Mangue family was then renting near Romeo's Pier. Ron and Jeanne remember seeing their beloved dog riding a piece of torn-up fencing out to sea. The children were convinced they would never see their dog again. Unbelievably, their pet was found safe a few days later, hungry on the beach. (Courtesy Maryanne Dimare.)

As a teenager in the early 1960s, Ron Mangue loved diving for abalone. Wearing elaborate gear, including a diving helmet made of brass and designed to deter rusting, a heavy canvas suit, and bulky weighted shoes, Ron got to know every underwater cave and cavern around Pillar Point. He discovered ancient shipwrecks like the English *Rydal Hall*, which had gotten lost near Pillar Point and sunk while carrying coal to San Francisco in the 1870s. He helped salvage the *Rydal Hall*'s anchor, now planted in one of the gardens in front of the Half Moon Bay Brewing Company. According to Ron, there are other old shipwrecks down there. (Courtesy Ron Mangue.)

During the 1970s, the Westinghouse Corporation bought up rural areas around the country for future development. The company acquired acreage on the Coastside and, with its partners, built the ShoreBird Restaurant. (Courtesy Jerry Koontz.)

In 2000, the Half Moon Bay Brewing Company acquired the exact site of the ShoreBird, constructed additions, and created the modern version of a string of historic restaurants. The Patroni House once stood close by, followed by Ida's, whose owner rented a building from developer Henry Doelger. (Courtesy Jerry Koontz.)

Ron Mangue was a dedicated abalone diver. Through his photographs, you can see how the diving attire changed over the decades from a clunky, astronaut-style uniform to something that fit like a glove. Here he shows off a pair of good-sized ab. (Courtesy Ron Mangue.)

67

Before an abalone entrée could be listed on the menu at Hazel's, Ida's, Nerli's, Ortisi's, or the Crab Cottage, it had to be processed. In this historic view of the abalone-processing shed interior, a worker takes the first step to prepare the abalone: a lot of pounding with a mallet to flatten and soften the meat. (Courtesy Larry Teixeira.)

You needed a lot of help from your friends in order to don the old-fashioned diving gear. Here Ernie Mangue gets assistance while putting on his weighted boots before a day of abalone diving off Pillar Point. In those days, fishermen did not earn very much, but they were frugal; owning one's own boat was very important. The *Ronnie Jean* was Ernie's first boat, named after two of his kids. One of his last boats, the *Wild Portugee*, was purchased from Capt. John Teixeira of Hazel's. (Courtesy Ron Mangue.)

In 1955, Ron Mangue prepares to slide into the water near Patroni's Wharf. Looking closely, you can see the second story of the Patroni House, then vacant. Ron loves to tell the story of the English ship *Rydal Hall*, which crashed into Whaleman's Rock near Pillar Point in 1876. Some of the crew drowned instantly, but incredibly, the survivors crawled up the tangled rigging, way up high on the mast. An expert diver, Ron Mangue found the ship's stern at 25 feet. John Koep, his longtime abalone diver friend, carried the ship's brass bell to the surface. (Courtesy Ron Mangue.)

Ida's 1950s location stood across the way from the original Ida's fish stand. The new, bigger place was named Ida's Princeton Fish Grotto, seen here with the Crab Cottage and Princeton Inn in the background. The Fish Grotto was rented from developer Henry Doelger, who owned most of the land in Princeton at the time. Some 20 years later, Ida and Ernie moved to their last location on Highway 1, the current site of Sam's Chowder House. (Courtesy Jeanne Bogue.)

This view of Ida's popular Princeton Fish Grotto was taken about 1959. The building is a classic example of the wharf-restaurant architecture of the time. (Courtesy Jeanne Bogue.)

From 1956 through 1965, "Tennessee" Ernie Ford had a smashing success with a television show. It could have been either the funky atmosphere or the wholesome seafood that brought him to Ida's, for he was seen regularly enjoying the prawns deep-fried in peanut oil. (Courtesy Jerry Ohlinger.)

This photograph was shot through a wet lens during the Christmas storm of 1955 when heavy rain flooded the streets of Princeton. Worse yet, the wild surf eroded 55 feet of the nearby bluffs. These cars appear inundated by the storm, passing the tired and neglected Patroni House. In the 1960s, Patroni's was finally razed and relegated to Coastside history. (Courtesy Ron Mangue.)

On a sunny day, the Patroni House reflects its glory as an infamous Prohibition roadhouse as well as the place where dignitaries met to discuss local matters. Next door stands a Standard Oil gas station. (Courtesy Ron Mangue.)

At Ida's restaurant, customers could order their fish or prawns deep-fried, grilled, or breaded. It was the 1950s, when times were simpler; there was nothing fancy on the menu. (Courtesy Jeanne Bogue.)

Ida moved from her well-known Princeton location to a new one not far away on Highway 1. The restaurant sported big picture windows overlooking the beautiful harbor, and every customer wanted a window table. Today the building is the site of the recently opened Sam's Chowder House. At Sam's, the walls are graced with vintage photographs of Ida and Ernie Mangue selling their fresh seafood at the original fish stand in Princeton. (Courtesy Jeanne Bogue.)

This wonderful aerial view provides a good sense of Princeton in the 1940s and early 1950s. At the left is the two-story Patroni House, and at the right is the Princeton Packers Cannery building. (Courtesy Mark Andermahr.)

The huddle of buildings making up the Princeton Packers Cannery once stood at this site. The cannery has been gone for decades, and in its place is this lovely grove of cypress trees. Princetonians, with their dogs and kids, enjoy the peaceful gem in the center of town. (Courtesy Jerry Koontz.)

Five
PIONEER DRAG RACERS AND MAGNIFICENT SURFERS

In the 1950s and 1960s, every teenager wanted a car. The automobile was a sign of freedom, especially in California. The boys wanted to get under their car's hood to tinker. They wanted their cars to look good and drive fast, and this led to informal racing on local streets. All that was required was a nod of the head and the "go" sign. Unfortunately, this kind of racing was dangerous, and some organization was necessary. It took committed adults to help the "hot-rodders" find a place to race safely and learn to be good competitors. The Half Moon Bay Airport was the perfect place on the Coastside. The airport was spacious and had little air traffic. First there were amateur contests, and the kids cheered when the professionals came. The HMB Drag Strip evolved as a major venue for the booming sport. Note the proud sign on the tower stating that Half Moon Bay was "Where World Records Are Broken!" (Courtesy Don Garlits.)

The biggest drag strip hero of all was "Big Daddy" Don Garlits. In this c. 1960 photograph, Garlits and his famous *Swamp Rat* complete a time trial run at the Half Moon Bay Drag Strip in the morning before the afternoon finals. Garlits is regarded by many avid fans as the "Babe Ruth" of the sport. He founded the Don Garlits Museum of Drag Racing near Ocala, Florida, which is a treat for the entire family, especially Half Moon Bay Drag Strip enthusiasts. (Courtesy Don Garlits.)

The Half Moon Bay Airport is pictured in the early days. During the 1950s and 1960s, the airport served as the venue for the Half Moon Bay Drag Strip, drawing hundreds of fervent spectators from all over California. (Courtesy Rosina Gianocca.)

"Big Daddy" Don Garlits's drag-racing nemesis was Don "The Snake" Prudhomme. Whenever Big Daddy and The Snake were competing, the crowds would swell. The Snake has won this time in 1964, as trophy girl Tammy Thomas presents Prudhomme with first prize. (Courtesy Mark Andermahr.)

Everybody knew Art Arfons's *Green Monster*, as he and his unusual dragster were regulars at the Half Moon Bay Drag Strip. With a painted monster baring its teeth on its front end, the dragster was funny in appearance but awesome in power, loaded with a gas-eating jet engine that reached speeds of 170 miles per hour. Note the familiar Princeton skyline in the background. (Courtesy Mark Andermahr.)

People are milling around, admiring a hot rod before the race started. Admission was 90¢. And on an occasional Sunday, there was a "Powder Puff Derby," so called because the competition was for women only. (Courtesy Mark Andermahr.)

Bud Riddell, a local who loved to race his 1963 Chevy, worked as a car mechanic out of a World War II–era Quonset hut in Princeton-by-the-Sea. Bud had to be a first-class auto mechanic, as the beatniks living at the Abalone Factory gave him all their business. (Courtesy Mark Andermahr.)

The San Bruno Lightning Rods and the South San Francisco Piston Pushers were among the early drag racers at the Half Moon Bay Airport in the 1950s when there were no seats and no judge's tower. The day appears to be a typical foggy one in July at the drag strip. It was not the most comfortable place to watch a sporting event, but the young men gathered here were diehards and rarely missed a Sunday. (Courtesy Don Walrod.)

San Bruno police officer Dick Walrod served as the adult advisor of the Lightning Rods. When the group needed a place to race legally, he offered help. Walrod was instrumental in arranging to use the airstrip in Half Moon Bay. The kids raced there for two years until the City of Half Moon Bay decided to make improvements and take out insurance for safety reasons. Not long after the strip was improved, professional drag racers started coming regularly. (Courtesy Don Walrod.)

Members of the San Bruno Lightning Rods are pictured with their cars. (Courtesy Don Walrod.)

The local Coast Riders of Half Moon Bay were clearly proud of their club jackets. They probably raced more than anyone else at the strip. (Courtesy Mark Andermahr.)

When stars like Garlits and Prudhomme were going to perform, the local kids rode their bikes, walked, or hitchhiked to the strip, perching themselves atop the roof of a barn or on the hillside. Sometimes all they could see was the end of the race when the parachutes opened. (Courtesy Rosina Gianocca.)

Jim McLennan (wearing a white shirt) brought professional drag racing to the Coastside. McLennan owned the Champion Speed Shop in Colma and had connections with all the big-time dragsters. (Courtesy Mark Andermahr.)

The biggest match race of all took place in 1966 between Don Garlits and Don Prudhomme. Highways 1 and 92 turned into parking lots as some 15,000 people came to root for Prudhomme because he was a native Californian. The race was run in three heats; two wins earned the trophy and the $5,000 purse. Garlits easily won the first heat, but Prudhomme came back with a win in the second. Then came the deciding heat. Garlits grabbed the lead early and was gone to the most satisfying victory of his career. He drove 50 miles before he remembered to claim his prize money. (Courtesy Mark Andermahr.)

In 1973, in a controlled burn, the drag strip's tower was destroyed. (Courtesy Mark Andermahr.)

"Big Daddy" Don Garlits is alive and well, running his Drag Strip Museum in Ocala, Florida. He autographed this photograph in 1998 for Burt Blumert, the author's companion. (Courtesy Burt Blumert.)

The drag strip is gone, but every year in April the Dream Machine show comes to the Half Moon Bay Airport, featuring fantastic cars of all kinds, boats, machines, and airplanes. A star everybody looks forward to seeing is local businessman and stunt pilot Eddie Andreini, seen here pointing at the *Barbarossa*. The *Barbarossa* is a World War II–era Soviet aircraft that fought the Nazis. (Courtesy Michael Wong.)

At a previous Dream Machine event, Coastside photographer Michael Wong got this spectacular shot of three World War II U.S. military aircraft. (Courtesy Michael Wong.)

Once hosting the greatest drag racers in the world, Princeton now proudly welcomes the greatest surfers in the world to Mavericks, where, at the right time of year, the waves can reach a height of 70 feet. Coastsider Jeff Clark is the public face of Mavericks, having surfed it for many years. He fashions tailor-made surfboards at his shop in Princeton and, when the waves cooperate, is the organizing force in drawing the masters to the giant waves near Pillar Point. Here Jeff Clark is shown in the middle of a surfing maelstrom. (Courtesy Aric Crabb.)

The big waves at Mavericks are not for the timid, as surfer Ross Clarke Jones demonstrates with perfect balance and agility. If you are ready to give it a try, get your wet suit ready. (Courtesy Aric Crabb.)

Princeton-by-the-Sea was famous as a failed Ocean Shore Railroad resort but reached the pinnacle of success during Prohibition and its time as a small Cannery Row. Today the giant waves at Mavericks have earned cozy Princeton a reputation as the hottest surfing spot in the world. Jeff Clark poses outside his surf shop on the way to the beach path leading to Mavericks. (Courtesy Jerry Koontz.)

The path to Mavericks is bounded by the Fitzgerald Marine Reserve's new Pillar Point Marsh. The area is idyllic, a beautiful place to walk with kids and dogs. (Courtesy Jerry Koontz.)

Jeff Clark is known for his meticulously hand-shaped surfboards made to ride waves anywhere in the world, big or small. (Courtesy Jerry Koontz.)

Six
PETE DOUGLAS AND THE BEATNIKS

Pete Douglas, his wife, Pat, and their kids were living in Menlo Park in the 1950s. On an intolerably hot day, Pete thought about the jazz houses on the beaches of Southern California where he was raised. The music was cool and the ocean breezes refreshing. He had to get back to the beach, and the nearest one was at Half Moon Bay. The probation officer and his family fled to the Coastside to cool off. They might not have known it at the moment, but they were in Miramar Beach. They found a little road fronting the ocean and a tiny house with a "For Sale" sign. The funky building had once been home to the colorful Ebb Tide Café. Pete decided to buy it on the spot and put into motion the plan that lead to the birth of the world-famous jazz house, the Bach Dancing and Dynamite Society. Music lovers all over the Bay Area celebrate the decision Pete Douglas made 50 years ago. (Courtesy Pete Douglas.)

Brothers Jack (left) and Pete Douglas relax in front of the old Ebb Tide Café, playing music on a hi-fi with speakers dangling out of the windows and urging passing cars to join the party. Pete wanted to create a music scene at Miramar Beach, one that would welcome all who shared his love of music, especially jazz. As the years passed, Pete would befriend top-level musicians from all over the world. This resulted in the early spontaneous music events at the Bach. (Courtesy Pete Douglas.)

When Pete Douglas was a probation officer, one of his clients was a teenager, an aspiring musician named Pat Britt, who got caught stealing bologna from a supermarket, leading to a petty theft conviction. When Pete learned Britt played the sax, he said, "Come on over, bring your friends, and jam all night." Pat Britt did exactly that; from that moment on, the music rarely stopped at the Ebb Tide Café. (Courtesy Pete Douglas.)

One evening, a spontaneous party scene developed at the tiny Bach, pictured here in its early days. Some guests were dancing to jazz when a group of others decided to explode dynamite on the beach. With the boom-boom in the background, Pete Douglas, in a change of mood, put the Bach Brandenburg Concertos on the hi-fi. The group continued dancing while periodic explosions could be heard outside on the beach. This led local resident Bob Swift to say, "We should call this place the Bach Dancing and Dynamite Society." (Courtesy Pete Douglas.)

Not much of anything was going on at Miramar Beach when Pete Douglas moved into the old Ebb Tide Café in 1958. At about the same time, construction began on the Pillar Point Breakwater at Princeton. The historic Amesport Pier was rapidly disintegrating, and the Palace Miramar, called Albert's Hotel in 1958, was a bit seedy. In this photograph, antique automobiles are displayed in front of the Albert's Hotel sign. Folks, including many politicians, came for the steak and crab cioppino. Albert's Bar was a hangout for the locals, who watched the ocean reclaiming the pier and made bets on when it would disappear completely. (Courtesy Pete Douglas.)

While Pete Douglas was developing his music scene at the Bach, another artistic fellow was practicing his craft at the opposite end of Mirada Road. Photographer Michael Powers fell in love with Miramar Beach and was in turn inspired by the lovely beach village. Powers, as independent-minded as the early Coastside settlers, built his house the way he wanted to. His geodesic dome was the first of its kind on the Coastside. John Morrall and author June Morrall pose in front of the home. (Courtesy Pat Levitz.)

Michael Powers's geodesic dome is shown in its natural setting. His property stands near the edge of the cliffs on Mirada Road overlooking the Pacific. Like Pete Douglas, Powers created his own scene, bringing together artistic and spiritual people. His friends say that his name suits his personality—one of boundless energy. (Courtesy Jerry Koontz.)

Artist Michael Powers stands in front of his unusual, hand-built, A-frame residence and studio. When walking along the beach trail, passersby are always stunned at this piece of art that serves as Powers's home. (Courtesy Michael Powers.)

In the center of Mirada Road, between the Bach and Michael Powers's unique residence, stands the Hastings House with a history going back to the early 1900s. Its location was just perfect, steps away from the Pacific Ocean. When the home went on the market, artist Linda Montalto Patterson and her classical guitarist husband, Richard Patterson, purchased it posthaste. (Courtesy Linda Montalto Patterson.)

Richard Patterson and his wife, Linda, stand in the beautiful, rose-filled garden behind the Hastings House. Today Linda hosts wedding ceremonies in this romantic setting. (Courtesy Linda Montalto Patterson.)

One of Pete Douglas's daughters and a neighbor's child play in the front yard of the Ebb Tide Café during its early days. Through the late 1960s and early 1970s, the Bach attracted the best Bay Area musicians, including Bola Sete, Michael White, John Handy, and Vince Guaraldi. In spite of the rock 'n' roll rage overwhelming popular audiences at the time, Pete Douglas never succumbed to the fashion of the moment and constantly sought first-rate artists across the musical spectrum. Pete was right, and new patrons flocked to the Bach. (Courtesy Pete Douglas.)

As the audiences began to overwhelm the tiny Bach beach house, Pete Douglas built a larger place on the same site in 1965. This photograph reveals how the new sections were integrated into the original structure. By now, Pete was consumed by the dream to create a perfect, intimate concert room to enhance the music and aesthetic needs of musicians and listeners. Operating now under its nonprofit status, Pete's dream for an unconventional jazz club is realized. (Courtesy Pete Douglas.)

Pete Douglas vividly recalls a very warm day in the fall of 1959. As the temperature approached 100 degrees over the hill in suburbia, cars and their overheated passengers streamed to Miramar Beach to cool off. There they found the typical music scene at the Bach. Getting out of their cars in celebration of the music and cool breeze, the throngs spontaneously joined in the festivities. Pete says that Michael McCracken, the beatnik leader who lived in the Abalone Factory at Princeton, appeared at the Bach that day with his legendary cast of characters, seemingly right out of the Jack Kerouac book *On the Road*. (Courtesy Pete Douglas.)

The legendary beatniks from the Princeton Abalone Factory joined the spontaneous party at Pete Douglas's Bach Society for the only time that day in 1959. This group of artists, painters, photographers, writers, and musicians had been forced out of North Beach by neighbors. The "refugees" then stumbled upon Princeton-by-the-Sea, an isolated place where they could be themselves and where their new neighbors did not care about their lifestyle. This painting, by artist and former beatnik Michael Bowen, is entitled *Grant Street*, the group's home before moving to Princeton. (Courtesy R. W. Bruch.)

When any of the characters of the Beat Generation traveled down Highway 1, they knew they would be well received at the Abalone Factory in Princeton. Michael McCracken, seen here, was the prototypical hardcore bohemian who painted abstract, floor-to-ceiling murals at the Abalone Factory, an old wood-frame building where abalone had been processed years earlier. If a traveling beatnik did not want to stop in Princeton, the only other place that might be hospitable was writer Ken Kesey's home in the redwoods of La Honda. Kesey himself was never considered "beat." The Princeton beatniks wanted to avoid being hassled by police, while some believed Kesey was attracting them. (Courtesy R. W. Bruch.)

Although not a beatnik, Ken Kesey, the author of *One Flew over the Cuckoo's Nest*, was another artist who lived in the redwoods not far from Princeton-by-the-Sea. (Courtesy author's collection.)

Carol McCracken, Michael's wife, was a singer some compared to Janis Joplin. Many of the young women who lived with the beats were from "good families." Carol's father was a wealthy Beverly Hills physician, and when she had a bit of a legal problem, famous San Francisco attorney Marvin Lewis was hired to defend her. (Courtesy R. W. Bruch.)

Janis Joplin with Big Brother and the Holding Company performs at a gathering for an event called the Love Pageant in San Francisco, an event organized by artist Michael Bowen, a significant resident at the Abalone Factory. Joplin's impromptu performance was to entice people to come to the pageant. We do not know if she succeeded in attracting paying customers that day, but Joplin did pack them in for her entire career. The singer also visited the Abalone Factory. (Courtesy R. W. Brunch.)

Artist Michael Bowen paints at the Abalone Factory. Not pictured are the goats that shared his space and clomped across the floor. To add to Bowen's distractions, exotic birds flew through the air, swooping near his head. You can imagine that the neighbors often wondered about these unusual young people. Bowen recalls that residents used wood stoves and fished for their food. A night rarely passed without 20 to 50 people enjoying dinner. The evening would close with a drum recital as everybody sat around a crackling fire. (Courtesy R. W. Bruch.)

Yoga is an ancient Eastern form of discipline that brings together one's physical and emotional well-being. It seems as popular today as it was 50 years ago. At the Abalone Factory, Michael Bowen practiced yoga, as evidenced by this stretch. (Courtesy R. W. Bruch.)

Novelist Ken Kesey and his friends, known as the "Merry Pranksters," were not the only ones who favored colorfully painted cars as they drove through the redwoods in the 1960s. Here Michael Bowen sits in one he decorated. At Princeton, the artists living in the Abalone Factory often traded their art for auto repairs. Since their cars were always breaking down, there must be an abundance of magnificent art hanging on people's walls or sitting in their attics. (Courtesy R. W. Bruch.)

Since 1958, Pete Douglas has remained true to his dream and continues to bring the best of jazz and classical music to Miramar Beach. Going to the Bach still feels like visiting a friend, sitting on the outdoor decks or in the comfort of Pete's living room, all with spectacular ocean views. In 2008, Pete, seen here with his assistant, Linda Goetz, will celebrate the 50th anniversary of the Bach Dancing and Dynamite Society, as well as his own 80th birthday. (Courtesy Jerry Koontz.)

Seven
THE NEW MAVERICKS

It has been about 100 years since Frank Brophy named his resort town after an Ivy League university, and Princeton-by-the-Sea has found a new prosperity. The restaurants are flourishing, although their style and menus are different from the old days. The current residents of Princeton want to live and work nearby, bringing about a fresh spirit to the old fishing village. A variety of fascinating businesses have set up shop using warehouse buildings and other unusual structures one would never have thought could work. And standing watch over it all is the new U.S. Air Force Tracking Station, which locals call the "giant golf ball." (Courtesy Jerry Koontz.)

The professional group called the Institute for the Study of Knowledge Management in Education (ISKME) chose Harvard Avenue as its headquarters. World-class surfers may come to Princeton for the big waves at Mavericks, but world-class clients come to ISKME for its expertise. The research institute is a nonprofit organization founded by former Columbia University professor Lisa Petrides. Pictured here from left to right are: (seated) Joy Marcus, Lisa Petrides, and Cynthia Jimes; (standing) Keri Morgret (in scuba gear), Thad Nodine (with surfboard), Amee Godwin (in hat), and Anastasia Karaglani. (Courtesy Jerry Koontz.)

Jeff Clark stands outside his Mavericks Surf Shop. Just a short walk from ISKME, this business reminds residents that Princeton is indeed a surfing town. While Mavericks was bringing world-class surfing to nearby Pillar Point, Jeff began making boards in a World War II–Quonset hut. Today customers come from all over the world to see him at his Harvard Avenue surf shop. (Courtesy Jerry Koontz.)

On Harvard Avenue, visitors can find desserts that are out of this world at Elegant Cheesecakes. Owner Susan Morgan adjusts an ornamental daisy on a cake ordered via the store's successful Web site, www.elegantcheesecakes.com. A sassy six-pack is also ready for shipping as a birthday surprise. Since 1988, Susan has run her cheesecake business on Harvard Avenue in Princeton. If you ask her why this location, she will say that she wanted a gorgeous, non-retail site close to home—and she's never regretted her choice. (Courtesy Jerry Koontz.)

Susan Morgan (right) stands with longtime employees Esther Huerta (center) and Minerva Jimenez outside Elegant Cheesecakes in Princeton. Depending on the ingredients and how intricate the design, a cake can run from $30 for a simple "naked" treat, to thousands for a super special event confection. Susan Morgan's magnificent cakes have been seen on MTV and on *Oprah*. (Courtesy Jerry Koontz.)

The 1946 Romeo's Pier and the 21st-century U.S. Air Force Tracking Station's "golf ball" atop Pillar Point offer a marked contrast in time and place. The federal government's military interest in this piece of California Coastside real estate is not new. As early as the 1890s, there was concern that a foreign army could land at Pillar Point and march across the hills undetected all the way to San Francisco. (Courtesy Jerry Koontz.)

There are not many shops in Princeton, but the brightly painted Nasturtium has been around for some years, and folks seem to smile when they visit there. (Courtesy Michael Wong.)

In the middle of Princeton is master artistic welder Bob Resch, designer of creative gates, staircases, and other accessories. Resch works with various metals, including bronze and steel. Princeton Welding has been a fixture in town for many years, and Bob Resch has won major awards for his work, which is sought after by those with modest budgets as well as the rich and famous. (Courtesy Jerry Koontz.)

The ultramodern curves of the Dayle Dunn Gallery make a startling impact on Mirada Road in Miramar. The gallery provides a beautiful place to walk through and a unique experience. (Courtesy Jerry Koontz.)

The Princeton Inn, still standing in town, has become the fine Italian restaurant Mezza Luna and has retained all the charm of the old days. If you are lucky enough to get a window table, you will stare out at the cypress tree park where the cannery and the Crab Cottage once stood. The American Legion is situated directly across the street. (Courtesy Jerry Koontz.)

Some of the staff who work at Mezza Luna pose at the front entrance to the restaurant. Pictured from left to right are Antonio Flaco, Fabian Noriega, Bernardo Jimenez, Rita Bellissario, Sacramento Marquez, and Teresa Mendez. (Courtesy Jerry Koontz.)

Local fishermen often hang out near the Ketch Joanne Restaurant. Joanne built up a loyal clientele who often sit outside watching and talking about the fishing boats and private yachts moored at the harbor. Next door you can sign up for either a day of fishing or whale watching. (Courtesy Jerry Koontz.)

These folks walking down Johnson Pier are probably going to buy some crabs or fish in season. They can purchase directly from the fishermen who advertise their catch at the harbormaster's office. (Courtesy Jerry Koontz.)

At the far end of Johnson Pier are commercial fish wholesalers the Three Captains and Morningstar Fisheries. Looking closely, you will see the ever-present "giant golf ball" like Big Brother watching over everything. (Courtesy Jerry Koontz.)

Fresh fish from the Three Captains, packed in ice, is ready to go to one of San Francisco's fine restaurants. (Courtesy Jerry Koontz.)

Pamela Moyce started Snow Angel eight years ago from her dining room table in nearby El Granada. Soon the business, which manufactures women's thermal underwear for the ski and outdoor sports industries, was doing so well that it had to move to a larger warehouse in Princeton-by-the-Sea. (Courtesy Jerry Koontz.)

Snow Angel's garments, like those seen on this mannequin, are manufactured in Brisbane, California, but design, sales, and customer service take place at the headquarters in Princeton. (Courtesy Jerry Koontz.)

In the middle of fishing season, working boats abound in the harbor. Some of the fishermen will offer their catch of the day to the public. (Courtesy Michael Wong.)

The *New Polaris*, moored at Pillar Point Harbor, has the special distinction of being owned and operated by Nat Johnson, who is in his early 90s. He is most likely the oldest fisherman in the harbor, having lived through more presidents than you can count on your fingers, though he would rather talk history than politics. (Courtesy Jerry Koontz.)

Princeton has also attracted high-tech businesses. Daniel and Celeste Bass of West Coast Surgical produce precision instruments for the medical field. Here they stand in front of their computer-controlled machines, definitely a symbol of the 21st century. (Courtesy Jerry Koontz.)

In the distance, the most impressive symbol of a new Princeton is the Harbor Village Resort and Spa, still under development at the time this book was written. Harbor Village looks out over the beautiful Pillar Point Harbor. Though under total local ownership, the project has been controversial since its inception because of its scope and size. (Courtesy Jerry Koontz.)

The Harbor Village Resort and Spa will feature a hotel with 85 open suites and 11 long-term apartments plus a shopping center and a two-story restaurant. The nearby land was once covered with acres of artichokes. (Courtesy Jerry Koontz.)

Those who visit or live at the Harbor Village Resort and Spa will indulge themselves with all the nice things in Princeton-by-the-Sea. However, there are many people who feel that this big project will change the area and that old Princeton will be lost forever. (Courtesy Jerry Koontz.)

If you have never seen the inside of an artist's lair, here is the warehouse interior of boatbuilder/contractor Howard White's private studio where he brainstorms. (Courtesy Jerry Koontz.)

This photograph puts us back on the path to Mavericks. When turning the corner pictured in the background, lo and behold, you will see the tip of Pillar Point, that historic landmark that defines the entire area. (Courtesy Jerry Koontz.)

Though not the prettiest in the harbor, this boat has the very best name: the *Princeton Special*. The fishing craft stirs memories of Hazel's *Miss Princeton* and the other boats now gone. (Courtesy Jerry Koontz.)

It was a sad day when O. B. Dooley's *Aloha* was beached. (Courtesy Larry Teixeira.)

The *Aloha* was beached just south of Hazel's, the restaurant owned by O. B. Dooley's wife. The event was the talk of the tiny fishing village. (Courtesy Larry Teixeira.)

Now that the *Aloha* was safe to work on, the salvaging could begin. (Courtesy Larry Teixeira.)

There actually was not much to salvage from the old *Aloha*, but O. B. Dooley did reclaim the engine and drive train. (Courtesy Larry Teixeira.)

The remains of the mortally wounded vessel are seen here. (Courtesy Larry Teixeira.)

Princeton and Miramar both have colorful histories. What the 21st century holds for both towns, nobody knows, but this is for sure: they will always have a special identity because of their unusual geographical location, because of the earlier people who have left their imprint, and because of the younger people who will arrive with their dreams, talent, and energy. (Courtesy Jerry Koontz.)

Across America, People are Discovering Something Wonderful. Their Heritage.

Arcadia Publishing is the leading local history publisher in the United States. With more than 4,000 titles in print and hundreds of new titles released every year, Arcadia has extensive specialized experience chronicling the history of communities and celebrating America's hidden stories, bringing to life the people, places, and events from the past. To discover the history of other communities across the nation, please visit:

www.arcadiapublishing.com

Customized search tools allow you to find regional history books about the town where you grew up, the cities where your friends and family live, the town where your parents met, or even that retirement spot you've been dreaming about.